Andy Warhol

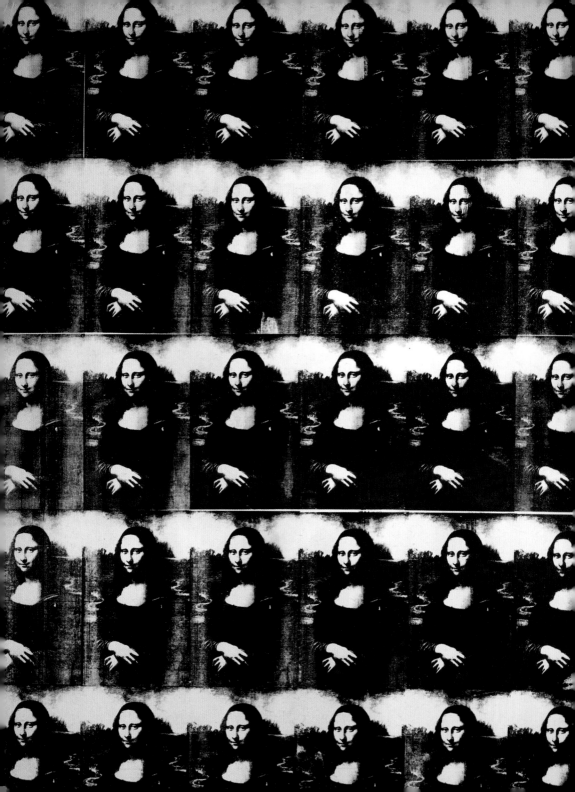

Andy Warhol

Stephanie Straine

Tate Introductions
Tate Publishing

1. Andy Warhol, 1950s.
Photograph by Melton-
Pippin (with pencil
adjustments to face).
The Andy Warhol
Museum, Pittsburgh

'I can draw anything': from Pittsburgh to Madison Avenue

Andy Warhol worked hard to erase Andrew Warhola. In the iconic
images of the pop artist wearing a silver wig and leather jacket at
the height of his 1960s fame, the shy, pale boy born in Pittsburgh in
1928 is nowhere to be seen. His early childhood did, however, have a
major impact on the artist he was to become, particularly his intensely
religious upbringing in the Ruthenian Catholic Church (close to the
Russian Orthodox tradition), his bouts of ill health and resulting
hypochondria, as well as the working-class poverty his family
experienced. His parents Andrej and Julia Warhola were immigrants
to the United States from Mikova, a small village now on the
Slovakian-Ukraine border, then on the edge of the Austro-Hungarian
Empire. Warhol only learnt English when he entered elementary
school; a hybrid dialect of Hungarian and Ukrainian known as 'Po
Nasemu' was spoken at home. Andrej Warhola became aware of his
son's prodigious artistic talent early on, and started saving money
to send him to college. Tragically, he would never see his son's later
success: he died suddenly in 1942, just as Andy was beginning high
school.

After completing a Bachelor of Fine Arts in Pictorial Design at the
Carnegie Institute of Technology in Pittsburgh, Warhol moved to New
York in June 1949 with the goal of becoming a commercial artist and
illustrator. His first job was to illustrate an article in women's fashion
magazine *Glamour*, appropriately titled 'Success Is a Job in New York'.
As part of his relentless efforts to seek commissioned work, in a letter
to a magazine editor that year he declared: 'I can draw anything.'[1]
It was also in 1949 that he officially changed his surname to the
Americanised Warhol – a decisive step in his reinvention.

As Warhol himself explained in 1975: 'I started as a commercial
artist, and I want to finish as a business artist … making money is art
and working is art and good business is the best art.'[2] This conflation

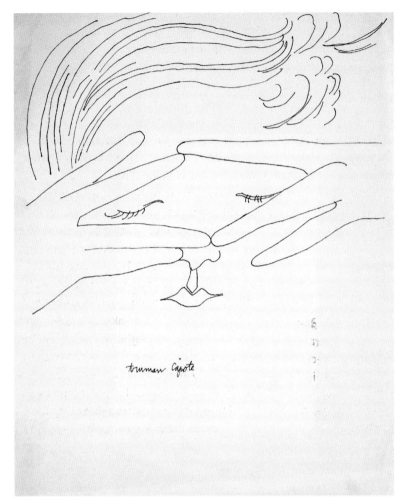

2. *Truman Capote* c.1954
Ink on paper
42.9 × 35.2
Hamburger Bahnhof –
Museum für Gegenwart,
Berlin

of art and commerce ties together the two halves of his career: his commercially produced drawings of the 1950s, and his later, wildly successful pop artworks. By changing how an artist produces his work, by running his studio as a factory-line production and diversifying those products across a huge range of artistic and pop-cultural means (from film, wallpaper and media installations, to TV commercials, celebrity magazines and portrait commissions), and by dissolving the idea of the artist-as-genius, Warhol radically redefined the parameters of artistic practice in the postwar period.

As a commercial illustrator in the 1950s, Warhol worked primarily on high-fashion advertising jobs, but extended his reach to many other avenues for design. In 1951 he produced a number of drawings that were selected by the major broadcast network CBS for the LP release of their documentary radio series *The Nation's Nightmare*. A drawing of a young man injecting drugs into his arm (fig.17) was used for the record sleeve's cover. The hard-hitting social message of the radio programme, linking recreational drug use to the rise in crime across America, is captured by Warhol's lithe line drawing that emphasises the outstretched arm and clenched fist.

In the summer of 1952, the exhibition preview for *Andy Warhol: Fifteen Drawings Based on the Writings of Truman Capote* was apparently attended by the author himself, something of a triumph for Warhol, who later explained the background to this event: 'I admire people who do well with words … and I thought Truman Capote filled up space with words so well that when I first got to New York I began writing short fan letters to him and calling him on the phone every day until his mother told me to quit it.'[3] The ink drawing *Truman Capote* 1954 (fig.2) demonstrates the young Warhol's ongoing desire to infiltrate New York's literary world, and is an early example of the portraits of public figures whom he admired, was inspired by, and perhaps even obsessed over. As the film theorist Peter Wollen has noted: 'For Warhol, the kind of love that counted was that of the fan for the star – love that linked private fantasy with public image, a love at a distance.'[4]

The blotted line

Warhol's graphic style at this time was characterised by his use of the blotted-line technique, which he first encountered while studying in Pittsburgh. The technique involved drawing in ink on non-absorbent paper, hinging a second piece of paper to the drawing, and then re-inking and blotting the first drawing to transfer its contents to the finer-quality sheet. Art historian Heiner Bastian explains that in this process: 'the copy indirectly takes precedence over the original: the print becomes the original'.[5] The blotted line gave the work a commercial, printed look while retaining the spontaneous graphic feel of freehand drawing. One of Warhol's early assistants, Nathan

Gluck, whom Warhol would eventually allow to complete whole commissions under his name, later said of the blotted-line technique: 'Another reason why he liked it so much [was that] by having your master drawing with which you made your blot, you could keep blotting it and redrawing it and blotting it each time and make duplicate images.'[6] This infinitely generative process provided Warhol with an early manifestation of his famed assembly-line productivity.

In 1955 Warhol landed a major commission for the shoe company I. Miller. His adverts appeared every week in the *New York Times*, and the following year he was awarded the prestigious Annual Art Director's Club Award for this work. In the same year, he published a book of shoe drawings, *À la recherche du shoe perdu* (fig.19), which was again a collaborative effort, with his mother handwriting the text of Ralph Pomeroy's accompanying poems. The exaggerated colours and over-the-top ornamentation underline the shoe's role as a fetish object, with the luxurious variety of designs assuming an erotic power.

Allocating much of the labour of drawing to assistants such as Gluck allowed Warhol more time for his private works, such as *Male Torso* 1956 (fig.18). This is one of many suggestive line drawings featuring young male subjects, reduced to body parts or

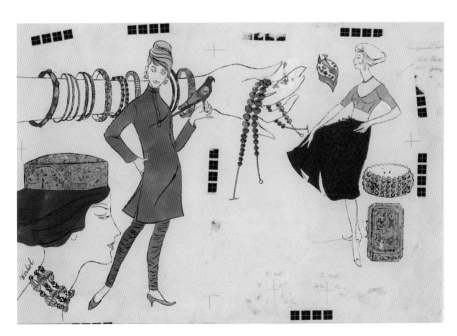

3. *Female Figures and Fashion Accessories* 1960
Ink, printed paper and dye on paper on board
43 × 62.8
Tate

4. *Journal American* c.1959
Ballpoint ink on paper
60.3 × 45.4
The Andy Warhol Museum, Pittsburgh

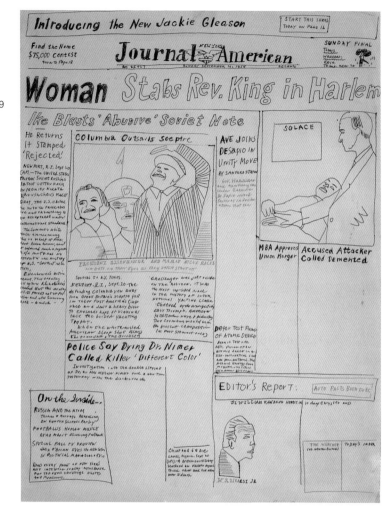

y 1956—
ommercially
u (can Art

close-ups under the artist's desiring gaze. Now basking in undeniable commercial success, in 1956 Warhol embarked upon a round-the-world trip with his close friend Charles Lisanby. The gold-leaf detailing of *Baboon* 1957 (fig.20) suggests the influence of his time in the Far East, particularly the gold furniture of Thailand.[7] *Female Figures and Fashion Accessories* 1960 (fig.3) shows a patchwork of high-fashion illustrations in the fragmentary, early stages of design and sketching: the posed mannequins (again drawn using the blotted-line technique) are surrounded by handwritten annotations and a variety

of costume-jewellery close-ups. This sheet of drawings appears to be preliminary work for a magazine commission, and in all likelihood its final appearance is purely the result of chance – Warhol often asked his friends to complete his drawings at the 'colouring parties' he hosted in New York cafés such as Serendipity.

Leaving the commercial world behind

Around 1960 Warhol set his sights on working exclusively as an artist, keen to move on from his career as an illustrator for hire. He achieved this aim in 1962; prior to this date commercial work still supported his attempts to become an artist. Now, rather than contributing to the advertisements themselves, Warhol began using the print culture of advertising and daily newspapers as subjects for his fine-art practice. *Journal American* c.1959 (fig.4) is a hand-drawn newspaper front page, but one that omits several sections and executes only schematic outlines of the photographic components. The stark headline 'Woman Stabs Rev. King in Harlem' hints at the unsettling territory that Warhol would soon stake out in his 'Death and Disaster' series. This ballpoint drawing is also important as a transitional work for Warhol: it retains something of the illustrator's craft, while focusing on the digestible daily news, the subject matter of the next phase of his work. The first fully realised painting from this period is thought to be *Advertisement,* made in April 1961 (fig.21). A hand-drawn composition of fragments traced from newspaper advertisements, this monochrome work imports the collage aesthetic common to commercial illustration that Warhol had spent a decade mastering.

Water Heater 1961 and Dr Scholl's Corns 1961 are further works based on advertisements clipped from newspapers (figs.22, 23). They still rely on the semi-expressive, gestural marks and drips of direct painting (affirming the overwhelming importance of abstract expressionism to artists of Warhol's generation), while demonstrating his emerging pop tendencies, particularly the embrace of branded products. Although these new, monochromatic works on canvas may appear radically different from his illustrations of the 1950s, the art historian Benjamin Buchloh has argued for the strong links between Warhol's two careers as a commercial then fine artist, given that 'the key features of his work of the early 1960s are prefigured in the refined arsenal and manual competence of the graphic designer'.[8]

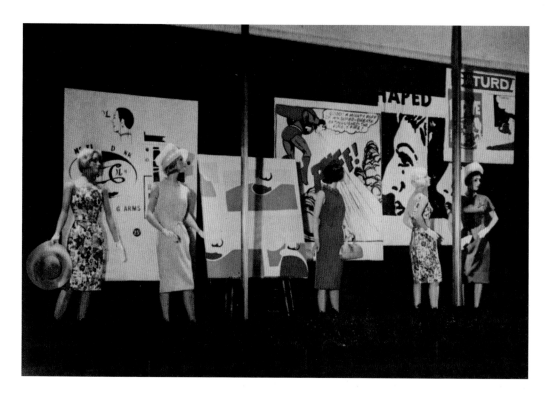

5. First exhibition of Warhol's paintings *Advertisement, Little King, Superman, Before and After I* and *Saturday's Popeye*, in a window display for Bonwit Teller department store, New York, April 1961 The Andy Warhol Museum, Pittsburgh

Before and After I 1961, one of a series of paintings based on the same advert, points to Warhol's deep understanding of the postwar American cult of self-improvement, while reflecting his own dissatisfaction with his appearance (fig.24). He had undergone a nose job in 1957, and claimed to be disappointed with the results. The doubling of the face across its moment of transformation hints at the monumental repetition to come in subsequent works. Warhol exhibited a selection from this group of new paintings as part of a window display for the New York department store Bonwit Teller, also in April 1961 (fig.5). This display returned these paintings to the commercial sphere, where they formed a literal backdrop for mannequins dressed in the latest fashion garments. The subject matter of these paintings, as well as newspaper advertisements, included comic strips and characters such as Dick Tracy. In this same year the eminent New York art dealer Leo Castelli declined to represent Warhol, since he feared these comic-strip works were too similar to the Ben Day dot paintings of Roy Lichtenstein, who was

11

already showing at Castelli. As a result, Warhol changed tack: 'Right then I decided that since Roy was doing comics so well, that I would just stop comics altogether and go in other directions where I could come out first – like quantity and repetition.'[9]

Turning pop

> You can be watching TV and see Coca-Cola, and you know that the President drinks Coke, Liz Taylor drinks Coke, and just think, you can drink Coke, too. A Coke is a Coke and no amount of money can get you a better Coke than the one the bum on the corner is drinking.[10]

A decisive moment for Warhol's painting came in the familiar form of a Coca-Cola bottle, and a visit from the filmmaker Emile de Antonio, whom Warhol later credited as the person 'I got my art training from'. Warhol first met de Antonio (a friend of the artists Robert Rauschenberg and Jasper Johns) in 1960. In his memoir of the 1960s, Warhol recalled an afternoon when de Antonio visited his studio to look at two paintings:

> One of them was a Coke bottle with Abstract Expressionist hash marks halfway up the side. The second one was just a stark, outlined Coke bottle in black and white. I didn't say a thing to De. I didn't have to – he knew what I wanted to know. 'Well, look, Andy,' he said after staring at them for a couple of minutes. 'One of these is a piece of shit, simply a little bit of everything. The other is remarkable – it's our society, it's who we are, it's absolutely beautiful and naked, and you ought to destroy the first one and show the other.' That afternoon was an important one for me.[11]

Considering the two paintings together, *Coca-Cola [2]* 1961 and *Coca-Cola [3]* 1962, de Antonio immediately grasped that it was the cold, 'no comment' rendering of the product and its logo that truly represented American society (figs.25, 26).[12] Both Coca-Cola works were at this point still created using the laborious method of tracing and hand-painting. This changed later in 1962, when Warhol began to use hand-carved rubber stamps in a hybrid method of painting/ printing that produced all-over fields of a single colour (again, a nod

to abstract expressionism and colour-field painting). In *S&H Green Stamps* 1962 and *Blue Airmail Stamps* 1962, the irregular grids betray the artist's hand, while varying pressure created subtle variations across the painting surfaces (figs.27, 28). These works (based on consumer trading and postage stamps) dissolve their everyday subject matter by extreme repetition into vast, near-abstract fields.

Painting and performance

Around 1962 Warhol began to attend contemporary dance performances in Greenwich Village at the Judson Memorial Church, influenced by Rauschenberg. Rauschenberg was the stage manager for the Judson Dance Theater group, who became known for their choreography based on everyday movements and repetitive gestures. *Let Us Now Praise Famous Men (Rauschenberg Family)* 1963 is a direct homage to the artist whom Warhol followed to Judson, made the year after they both (almost simultaneously) began to use the photo-silkscreen technique (fig.36). *Dance Diagram [1] (Fox Trot: 'The Double Twinkle-Man')* 1962 (fig.29) is one of a series that pointed to Warhol's new awareness of performance, but also his attraction to the clean lines and legibility of the diagram (like a logo, in many ways). This set of paintings was originally exhibited directly on the floor of the Stable Gallery in November 1962, encouraging visitors to try out the dance moves depicted, and suggesting the correspondences between the repetitive steps of a dance sequence and the rhythmic repetitions of Warhol's own painting procedure.

 Do It Yourself (Seascape) 1962 is again one of a series that made the mechanical base of painting explicit (fig.30). The seascape is the only example within the series (comprising a range of bland still lifes and landscapes common to paint-by-numbers) that has been 'completed' according to the numbered template, in what the art historian Hal Foster calls a 'prosaic, almost robotic kind of picture making'.[13] Just as the Judson performers were draining dance of its balletic skill, Warhol was draining painting of personal, creative expression.

Discovering the silkscreen

In August '62 I started doing silkscreens. The rubber-stamp
method I'd been using to repeat images suddenly seemed too
homemade; I wanted something stronger that gave more of an
assembly-line effect.[14]

In July 1962 Warhol had his first solo exhibition as a fine artist, which
took place not in New York but Los Angeles, at Irving Blum's Ferus
Gallery. Without travelling to LA himself, Warhol chose to show
Campbell's Soup Cans 1962 (fig.31), made by silkscreen printing the
familiar soup can image onto thirty-two small canvases. He then
hand-stencilled the separate soup flavours, including the brand's
entire product range at the time. At Ferus the small canvases were
arranged along a single, narrow shelf, mimicking a grocery-store
display. It is notable that the silkscreen method of printmaking was
originally developed for commercial use; Warhol, like Rauschenberg,
utilised it to disrupt traditional hierarchies of artistic techniques.
Campbell's Soup Cans became central to Warhol's impending
celebrity as an artist. It was the personal association of Campbell's
Soup that had led him to select it as a subject, famously explaining
that he had eaten it for lunch every day for twenty years.

The first works that Warhol made using the photo-emulsion
silkscreen process were portraits of the actors Troy Donahue and
Warren Beatty.[15] These were closely followed by the perfectly pop-
defining Marilyn works, among them *Marilyn Diptych* 1962 (fig.32). It
was the sudden death of Monroe on 4 August 1962 that prompted
Warhol to choose her for his work. The image he used for all Marilyn
silkscreens was cropped from a publicity still of the actress taken
for her 1953 film *Niagara* almost a decade before. Repurposed after
her death, it memorialised Marilyn at the height of her fame, while
simultaneously becoming the foundation for Warhol's degradation
of the photographic image – as *Marilyn Diptych* demonstrates in
its monochrome panel, across multiple-image frames the printing
blurs and conceals the actress's face, finally rendering it a ghostly
apparition. Warhol took Marilyn's flawless screen image and cropped,
fragmented and obscured it, all the while heightening its undeniable
potency. The ultimate example of this can be seen in *Marilyn Monroe's*

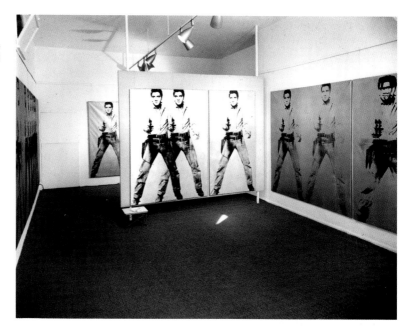

6. Installation view of *Andy Warhol*, Ferus Gallery, Los Angeles, September – October 1963 Courtesy Frank J. Thomas Archives

Lips 1962, in which Monroe's iconic pout is isolated and multiplied across a repetitive grid, taking on a supreme legibility even as it hints at the corrosive aspects of the fame that often reduced her to mere body parts (fig.33).

Monroe was not the only superstar actress to be selected by Warhol. Elizabeth Taylor became the subject of another epic sequence of paintings beginning in 1963, including *Blue Liz as Cleopatra*, where the silkscreen printing's progressive blurring and darkening brings her image to the point of disintegration (fig.34). Repetition here creates difference, rather than monotony. Warhol's disruptive technique mirrors the dramatic narrative of Taylor's life at the time: as with Marilyn, Warhol chose Liz not simply for her unparalleled fame, but also because it was a time of illness and professional crisis for the actress.

In 1963 Warhol had a second exhibition at the Ferus Gallery, where he showed his Liz portraits alongside another iconic American figure, Elvis Presley, in the new 'Silver Elvis' series (fig.6).[16] That same year Leonardo da Vinci's *Mona Lisa* had travelled to the United States, where it was seen by more than 1.7 million people

Blue Liz

15

in Washington DC and New York. Warhol responded by making the work *Thirty Are Better Than One* 1963 (fig.35). Both disrupting the pop obsession with modernity by recycling this Renaissance masterpiece, and undermining the idea of its intrinsic uniqueness by making the perverse assertion that thirty Mona Lisas would be 'better' than one, Warhol rendered the da Vinci work equivalent to his contemporary celebrity images – something to be recycled, repeated and destabilised.

With Warhol's move to a building that would become known as the Factory at 281 East 47th Street towards the end of 1963, his studio established itself as both a site of artistic production and a meeting place for New York's avant-garde underground scene. Billy Name was responsible for creating the Factory's silver look, covering the walls with silver foil and spray-painting every other surface with silver paint (perhaps not coincidentally, 1963 was the year in which Warhol began to wear silver wigs).

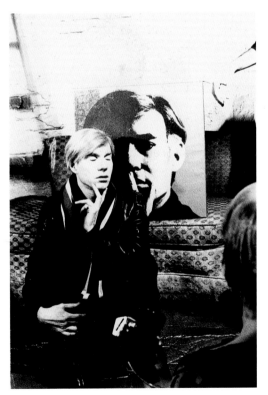

7. Warhol with a self-portrait, Silver Factory, 1967
Photograph by Billy Name

8. CBS television interview with Andy Warhol and Ivan Karp, The Factory, 47th Street, New York, 1964
Photograph by Billy Name

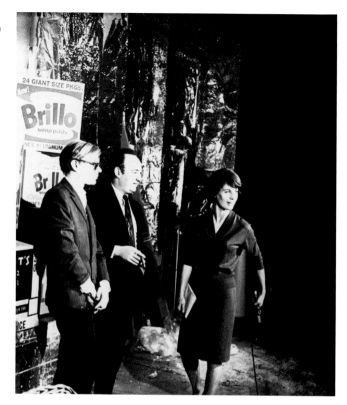

America's trauma

> When you see a gruesome picture over and over again, it doesn't really have any effect.[17]

Between 1962 and 1964 Warhol developed what would come to be known as his 'Death and Disaster' series, beginning with *129 Die in Jet!* 1962 (fig.37).[18] His recalibration of profoundly disturbing images of death and disaster underscores his detached, almost blank persona, which proved crucial to the work's production-line mentality. Some art historians have suggested – despite the artist's insistence that repetition numbed the effect of his source pictures – that there is a kind of 'traumatic realism' in these works that succeeds in rupturing the silkscreened surfaces, reinstating the true horror of these events.[19] In works such as *Red Disaster* 1963/1985, *Orange Car Crash (Orange Disaster) (5 Deaths 11 Times in Orange)* 1963 , and *Saturday*

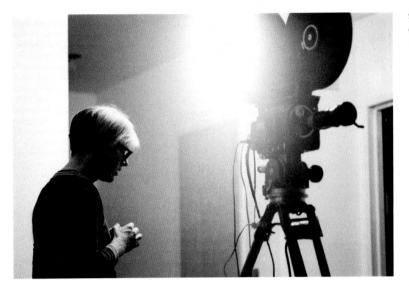

9. Andy Warhol with camera, 1967
Photograph by Billy Name

Disaster 1963–4, Warhol avoids melancholy, but retains a sense of humanity amidst the mechanised repetition (figs.38–40). Culling his source imagery from photographic agencies supplying mainstream magazines including *Life*, often he would choose those agency photographs deemed too graphic or upsetting to publish.

The *Electric Chair* works utilised the same source image repeatedly, in single and multiple iterations (figs.43, 44). This is the chair from New York's notorious Sing Sing prison that was used in 1953 to execute Julius and Ethel Rosenberg, accused of being Soviet spies. *Birmingham Race Riot* 1964 again used potent contemporary subject matter, this time addressing the violence of the civil rights movement, as police turned against protestors (fig.45). This silkscreen image is based on a photograph from the 17 May 1964 issue of *Life*, documenting the activism and demonstrations in the South, specifically Alabama.

At the intersection of Warhol's dual fascination with fame and death, *Nine Jackies* 1964 united a repeating celebrity image with a tragic subject matter (fig.46). Based on a cropped and isolated press photograph of Jackie Kennedy moments before the assassination of President John F. Kennedy, this painting demonstrates Warhol's use of emotive visual sources deeply embedded in public consciousness. As Warhol said: 'I'd been thrilled having Kennedy as a president; he

10. Andy Warhol during his *Flowers* exhibition at the Galerie Ileana Sonnabend, Paris, 1965.
Photograph by Harry Shunk and János [Jean] Kender

was handsome, young, smart – but it didn't bother me that much that he was dead. What bothered me was the way the television and radio were programming everybody to feel so sad.' [20]

Abandoning painting

In 1963, Warhol began to make movies. *Sleep* 1963 was his first film, made with a 16mm Bolex camera, and shows the poet John Giorno sleeping in extreme close-up (fig.41). Although over five hours long, the film was in fact 'faked': Warhol looped a much shorter sequence repeatedly, in a process akin to the silkscreen's repetition. Both *Sleep* and *Empire* 1964 (fig.42) are black and white films, with no sound and a fixed camera position, of interminable duration. Cinematic narrative and movement are replaced with a deadpan focus on one essential component of film: the passage of time. The artist described his early approach to filmmaking by saying: 'We were shooting so many, we never even bothered to give titles to a lot of them. Friends would stop by and they'd wind up in front of the camera, the star of that afternoon's reel.'[21] The excessiveness of the Factory's film production and the raw, unedited nature of what was recorded consumed Warhol's artistic interest during the mid-1960s, to the extent that he began to think about giving up painting completely.

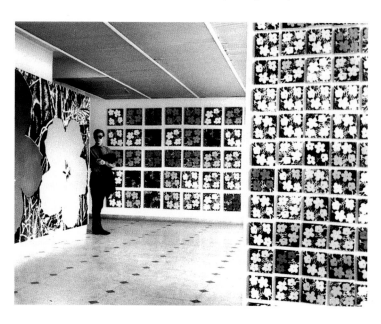

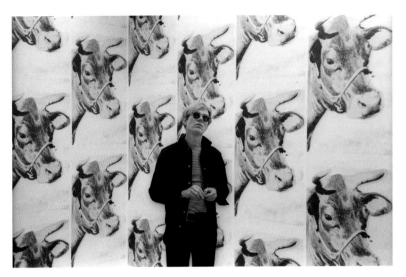

11. Warhol with his 'Cows' wallpaper at the Leo Castelli Gallery, New York, 1 April 1966 Photograph by Fred W. McDarrah

In Warhol's *Brillo Boxes* 1964 he took the silkscreen technique he had by now perfected and swapped canvas for sculpture (fig.47). Consumer packaging became a work of art as pure surface. Some critics held up the *Brillo Boxes* as proof that Warhol was criticising the commodification and emptiness at the core of America's postwar consumer culture; whether this is accurate is uncertain. Warhol never gave anything away: he did offer up images of everyday consumer goods for contemplation, but turned himself and his name into a highly profitable brand in the process, eliciting intense media interest.

In May 1965, Warhol dramatically declared that he was giving up painting for filmmaking, on the occasion of his *Flowers* exhibition in Paris (fig.10): 'I decided it was the place to make the announcement I'd been thinking about making for months: I was going to retire from painting. Art just wasn't fun for me anymore; it was people who were fascinating and I wanted to spend all my time being around them, listening to them, and making movies of them.'[22] Although his painting 'retirement' would not last for long, this focus on filmmaking returned Warhol to the fashion world. The very same *Life* magazine that he had scoured for disaster images published a fashion shoot of models with his films projected onto their outfits, creating a living canvas.

Warhol's short, filmed portraits known as the *Screen Tests*

captured notable visitors to the Factory such as Lou Reed, Dennis Hopper and Susan Sontag (fig.49).[23] *Screen Tests* exposed their subjects to the intense psychological pressure of 'performing' in front of the camera, with no notes or direction – sometimes not even a camera operator was present. Almost five hundred were made, and although called 'screen tests' they were works in themselves: no one was 'testing out' for another film.[24] Thus there was no cinematic idealisation – only a person laid bare, in an act of total exposure.[25]

The dual-screen film *Outer and Inner Space* 1965 operated more like an immersive installation, enveloping the viewer (fig.48). This work, thought to be the first ever use of videotape in a work of art, featured Warhol's ultimate muse of the mid-1960s, the society girl Edie Sedgwick. Edie is filmed in front of a monitor playing a video recording of herself, the duplication confusing the boundary between her pre-recorded image and live self. Another work that signalled the artist's move from painting to installation was *Silver Clouds* 1966 (fig.50). Warhol identified these silver balloons as paintings capable of floating away, all surface and no content. They were the colour of the

12. *Pop-Op Rock*
Screenprint on paper
50.8 x 35.5
Tate

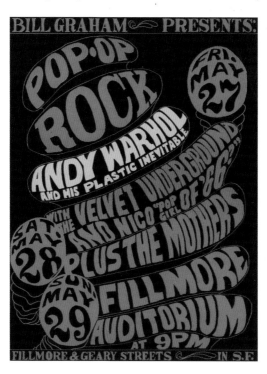

Factory, made of a new synthetic material in the burgeoning Space Age. Also shown in the same exhibition was his 'Cows' wallpaper of 1966, which modernised a traditional pastoral subject with a psychedelic injection of colour.

By diversifying his production outwards from fine art, Warhol also negotiated a move into the music business. He had met the rock band The Velvet Underground at the end of 1965 and by the following year he was acting as their manager. Together, they embarked upon what became known as the *Exploding Plastic Inevitable* (fig.12) – a multimedia fusion of rock concert, film installation and performance happening that toured across the United States during 1966–7. Warhol also designed the peel-able banana record sleeve for *The Velvet Underground & Nico* album in 1967 (fig.51).

Warhol's near-continuous filming during 1966 eventually produced the feature-length film *Chelsea Girls*, co-directed with Paul Morrissey and shot on location at the Hotel Chelsea and the Factory (fig.52).[26] *Chelsea Girls* became his most successful film yet, screening at many uptown movie theatres and gaining an audience beyond the small avant-garde crowd involved in The Film-Makers' Cooperative, where Warhol had shown his films since 1963.

The shooting

As the energy of the 1960s began to dissipate, with extreme drug use overwhelming the lives of many of Warhol's superstars, including Edie Sedgwick, the artist made the decision to move the Factory to 33 Union Square West in February 1968.[27] On 3 June that year, the actress Valerie Solanas entered the Factory and fired a gun at Warhol and the art critic Mario Amaya, who was visiting the studio. Warhol was seriously hurt in the unprovoked attack. Solanas had briefly featured in one of his films, but was no more than a bit player on the Factory scene. She gave herself up to police on the same day, claiming that Warhol had 'too much control' over her life. The front page of the *New York Daily News* announced the shooting on the following day, 4 June 1968 (fig.13). That evening Robert F. Kennedy would be assassinated in Los Angeles.

Warhol recounted the incident in his memoir: 'I said, "No! No, Valerie! Don't do it!" and she shot at me again. I dropped down to the floor as if I'd been hit – I didn't know if I actually was or not. I tried to

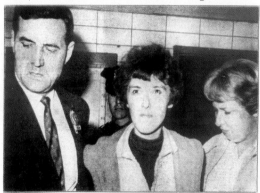

FINAL

DAILY NEWS
NEW YORK'S PICTURE NEWSPAPER ®

8¢ · 10¢

Vol. 49, No. 296 · New York, N.Y. 10017, Tuesday, June 4, 1968 · WEATHER: Sunny and warm.

ACTRESS SHOOTS ANDY WARHOL
Cries 'He Controlled My Life'

'Flower Child' Surrenders. Detective and policewoman (r.) escort actress Valerie Solanas, 28, into E. 21st St. station to be booked in shooting of pop art movie man Andy Warhol at his 33 Union Square West office yesterday. Last night, Valerie surrendered to a cop in Times Square, allegedly admitting shooting, and saying: "I am a flower child." Warhol is in critical condition. His associate, Mario Amaya of London, also was shot. —*Stories p. 3; other pics. centerfold*

crawl under the desk. She moved in closer, fired again, and then I felt horrible, horrible pain, like a cherry bomb exploding inside me.'[28] After three months of recuperation, Warhol returned to work. His torso was so seriously scarred by the emergency surgery that he was forced to wear binding surgical corsets underneath his clothing. The massive impact of the shooting would affect his health for the rest of his life. The heady social mix of the first, silver Factory that had lingered on at this new location was completely destroyed by Solanas's violent incursion into Warhol's world. He no longer blithely allowed unknown people to hang out at the studio, instead installing security precautions such as bulletproof glass.

Although the shooting profoundly injured Warhol, superficially at least his career barely paused. Many art historians have argued, however, that after the shooting his artistic practice never regained

MPACT SHOOTING

the breathless momentum and daring innovation that marked the period 1962–68. Perhaps it is also accurate to say that by the beginning of the 1970s, Warhol was close to achieving what he set out to do: to become 'a business artist', someone for whom 'good business is the best art'.

Success and shadows: Warhol's 1970s

In 1969 Warhol launched *Interview* magazine with John Wilcock, a glossy monthly title that would come to define the glamorous era of 1970s celebrity, fashion and music (figs.14, 56). Continuing his involvement with the music business, Warhol devised the concept for The Rolling Stones' *Sticky Fingers* LP in 1971 (fig.53). The close-up photograph of a male model's jeans-clad crotch (complete with working zipper) recalls the *Male Torso* (fig.18) drawing from fifteen years earlier.

An intense use of colour and exaggerated painterly gesture characterise the politically charged *Mao* portraits of 1972–3, large-scale works that were painted after President Nixon and Mao Zedong's historic meeting in February 1972, which opened up American trade with China (fig.54). In the latter half of the 1970s Warhol renewed his preoccupation with mortality, most overtly in

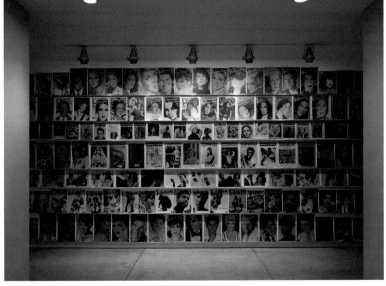

14. Installation of Warhol's *Interview* magazine (1969–89) at the Andy Warhol Museum, Pittsburgh, 1994

15. *Statue of Liberty* 1986
6 photographs, gelatine silver print on paper, and thread
Overall 69.5 × 80.5
Tate

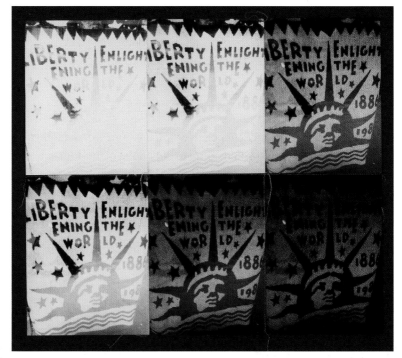

mid-late 70s;
mortality

Skulls 1976, paintings that used the human skull as shorthand for the inevitability of death, in the manner of historical *memento mori* works (fig.55). On the subject of death, Warhol was characteristically evasive: 'I don't believe in it, because you're not around to know that it's happened. I can't say anything about it because I'm not prepared for it.'[29]

Abstraction
my fig is
1/8 w/ AE

In *Shadows* 1979, Warhol's imagery edged towards abstraction (fig.57). As photographic silkscreens of shadows of unidentified objects in Warhol's studio, the *Shadows* are perhaps the most ambiguous of his later works. They occupy a space between representation and abstraction, and as such can be viewed in relation to the skull paintings, which similarly point to a threshold, this time between life and death.[30] Shadows also seeped into Warhol's self-portraits, such as the Polaroid *Self-Portrait in Profile with Shadow* 1981, which makes overt the malevolent, deathly quality of the shadow in relation to the body (fig.58).

Inkblots and icons

In the final years of his life, Warhol continued this strand of stark self-examination. This is demonstrated by the unflinching *Self-Portrait* 1986, produced the year before his death, in which the artist's gaunt face emerges from absolute blackness, saturated in blood-red paint (fig.60). Warhol's 1980s work referenced earlier subjects and motifs (remaking the Campbell's Soup Cans, for instance), while continuing to push at the limits of abstraction, as initiated by the *Shadows* and continued by the *Rorschach* works of 1984 (figs.57, 59). During the 1980s the artist also made two cable-television programmes, *Andy Warhol's TV* and *Andy Warhol's Fifteen Minutes* (the latter for MTV), in which he interviewed actors, musicians, artists and public figures, asking banal questions in his deadpan drawl, often focusing on his continued fascination with celebrity.

While his MTV show was building a wider audience, the artist embarked on an extended series of monumental silkscreens based on Leonardo da Vinci's *Last Supper* 1495–8. Warhol's paintings were based not on the fresco itself but instead a poor-quality twentieth-century reproduction, once again maintaining distance from his

16. *The Last Supper* 1986
Acrylic paint and
silkscreen ink on canvas
198.1 × 777.2
The Andy Warhol
Museum, Pittsburgh

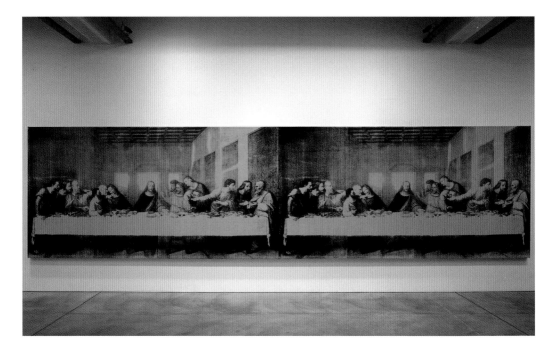

source material and inverting the relationship between original and copy. These works were commissioned in 1986 for an exhibition space directly opposite Santa Maria della Grazie, the site of da Vinci's fresco in Milan (fig.16). In what was to be his final series of works, Warhol returned to his devout religious upbringing and revealed his still deeply held Catholicism in a spectacular pop-cultural homage to one of the Church's undisputed masterpieces.[31]

On 22 February 1987, only a month after his *Last Supper* exhibition opened in Milan, Warhol died unexpectedly at the age of fifty-eight, following complications from a gall-bladder operation. His vast and diverse output across four decades, realised through strategies of appropriation, repetition and collaboration, fundamentally changed the terrain of art in the postwar period, anticipating the multimedia, interdisciplinary nature of much contemporary art. His legacy continues to startle and provoke.

17
'The Nation's Nightmare'
1951
Ink, graphite and acetate
on paper
37.1 × 34.5
Tate

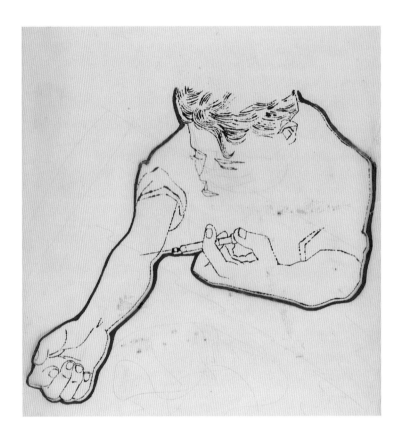

18
Male Torso 1956
Ink on paper
42.5 × 34.5
Tate

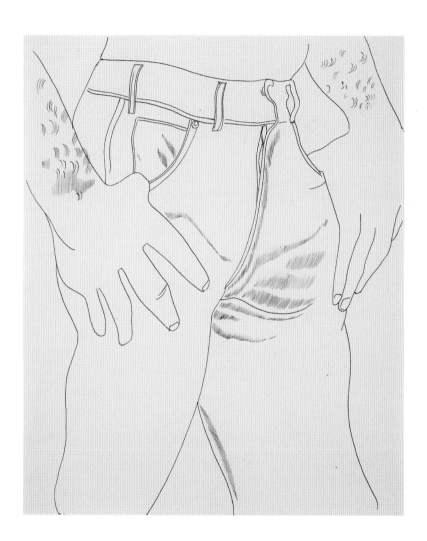

19
Andy Warhol in
collaboration with Ralph
Pomeroy
Untitled from *À la
recherche du shoe perdu*
by Ralph Pomeroy, 1955

Photolithograph with
watercolour additions
24 × 34.8
The Museum of Modern
Art, New York

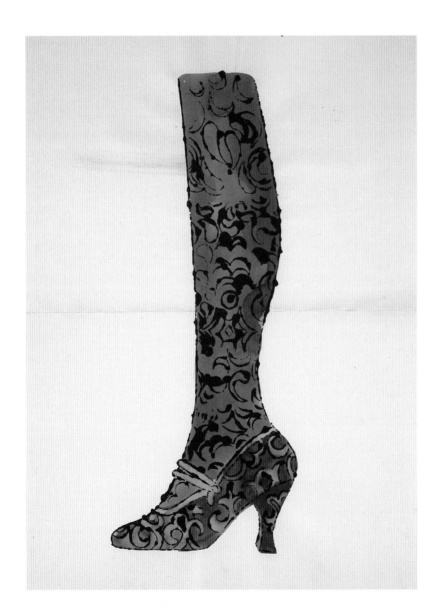

20
Baboon 1957
Ink, gold leaf, graphite and
gouache on paper
45 × 71.1
Tate

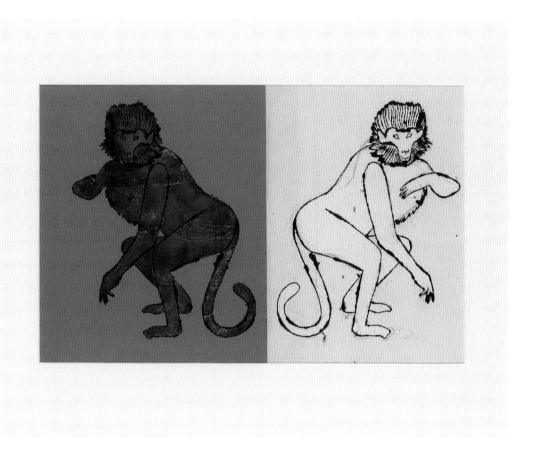

21
Advertisement 1961
Water-based paint and
wax crayon on cotton
177.2 × 133
Hamburger Bahnhof –
Museum für Gegenwart,
Berlin

22
Water Heater 1961
Casein on canvas
113.6 × 101.5
The Museum of Modern Art,
New York

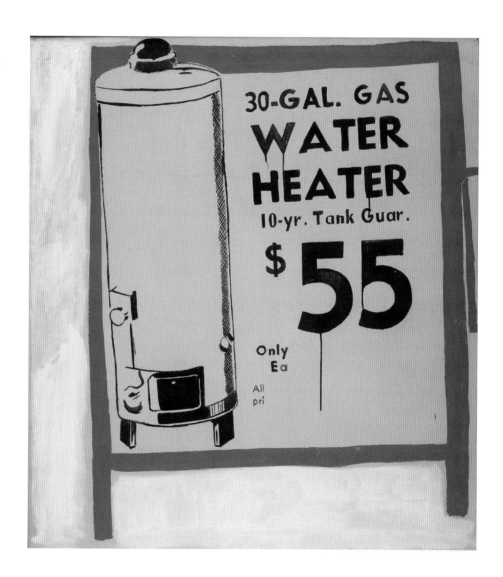

23
Dr Scholl's Corns 1961
Casein and wax crayon
on canvas
121.9 × 101.6
The Metropolitan Museum
of Art, New York

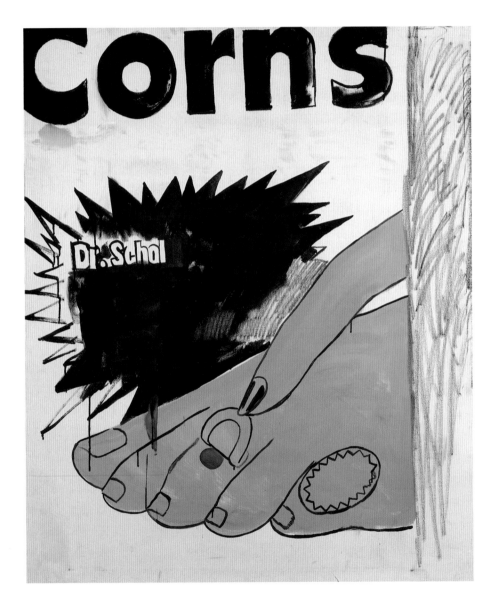

24
Before and After I 1961
Casein on canvas
172.7 × 137.2
The Metropolitan Museum
of Art, New York

25
Coca-Cola [2] 1961
Casein and crayon on canvas
176.5 × 132.7
The Andy Warhol Museum,
Pittsburgh

26
Coca-Cola [3] 1962
Casein on canvas
182.8 × 137.6
Private collection

27
S&H Green Stamps 1962
Silkscreen ink on synthetic
polymer paint on canvas
182.3 × 136.6
The Museum of Modern Art,
New York

28
Blue Airmail Stamps 1962
Acrylic paint on canvas
50.8 × 40.6
Collection Uli Knecht,
Stuttgart

29
Dance Diagram [1] (Fox Trot: 'The Double Twinkle-Man') 1962
Casein and graphite on canvas
183.5 × 137.8

MMK Museum für Moderne Kunst, Frankfurt am Main

30
Do It Yourself
(Seascape) 1962
Acrylic paint, graphite
and transfer lettering on
canvas

137.8 × 183.5
Hamburger Bahnhof –
Museum für Gegenwart,
Berlin

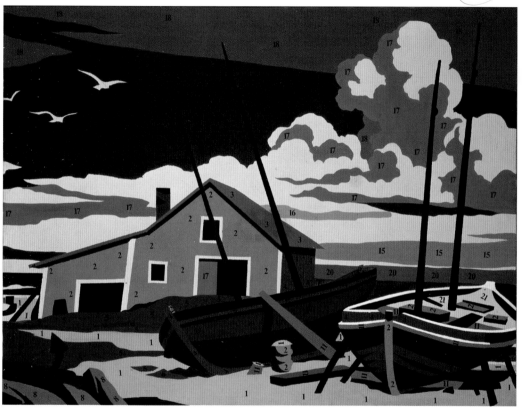

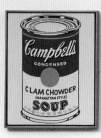 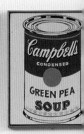

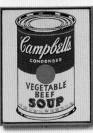 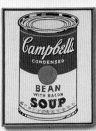 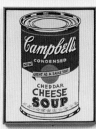 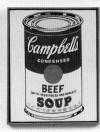 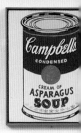

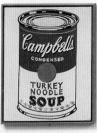 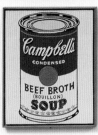 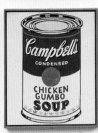 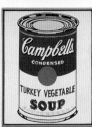 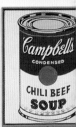

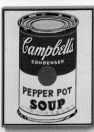 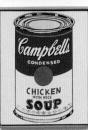 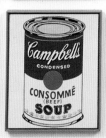 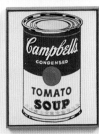 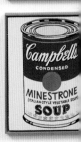

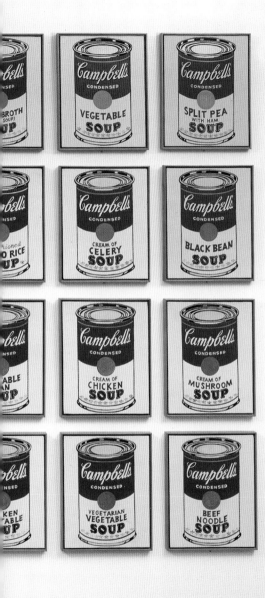

31
Campbell's Soup Cans
1962
Synthetic polymer paint
on canvas
Thirty-two parts, each:
50.8 × 40.6
The Museum of Modern
Art, New York

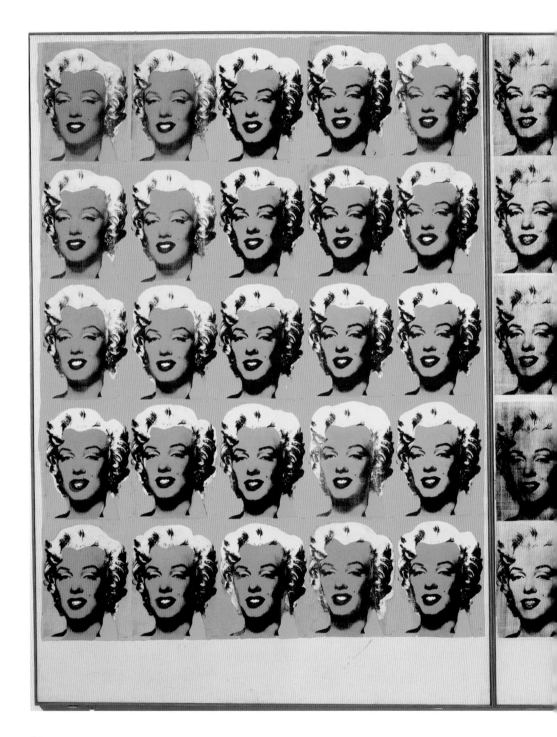

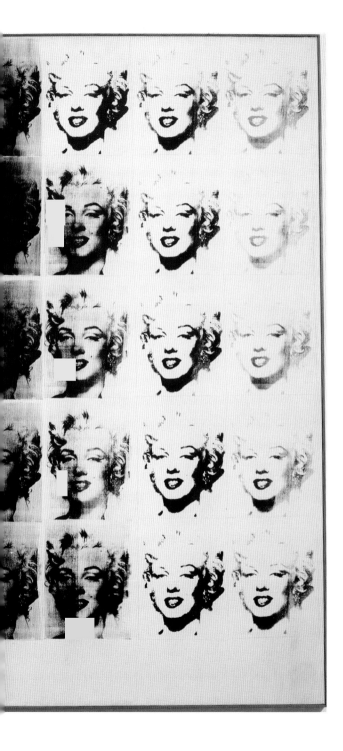

32
Marilyn Diptych 1962
Acrylic paint on canvas
Two parts, each:
205.4 × 144.8
Tate

33
Marilyn Monroe's Lips
1962
Synthetic polymer,
silkscreen ink and graphite
on canvas
2 panels: 210.7 × 204.9;
210.7 × 209.7

Hirshhorn Museum
and Sculpture Garden,
Smithsonian Institution,
Washington DC

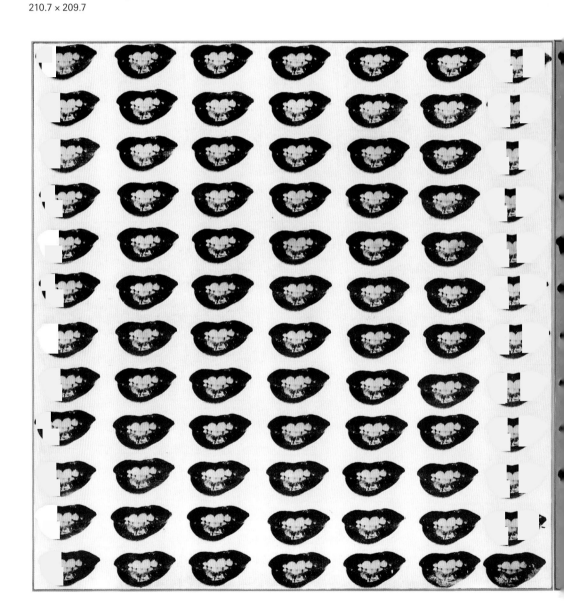

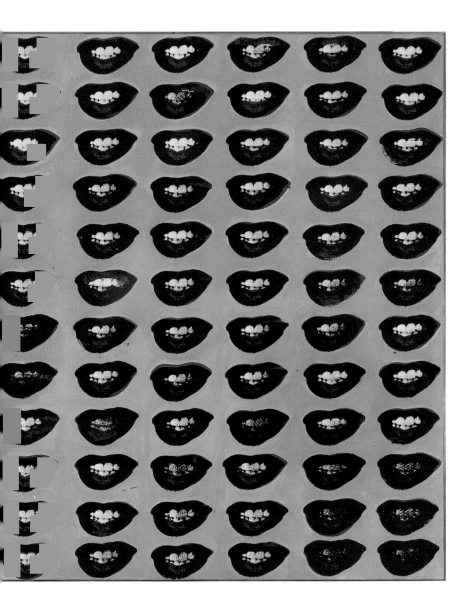

34
Blue Liz as Cleopatra 1962
Acrylic paint, silkscreen
ink and graphite on canvas
208.9 × 165.1
Daros Collection,
Switzerland

35
Thirty Are Better Than One
1963
Silkscreen ink and acrylic
paint on canvas
279.4 × 240
The Brant Foundation,
Greenwich, Connecticut

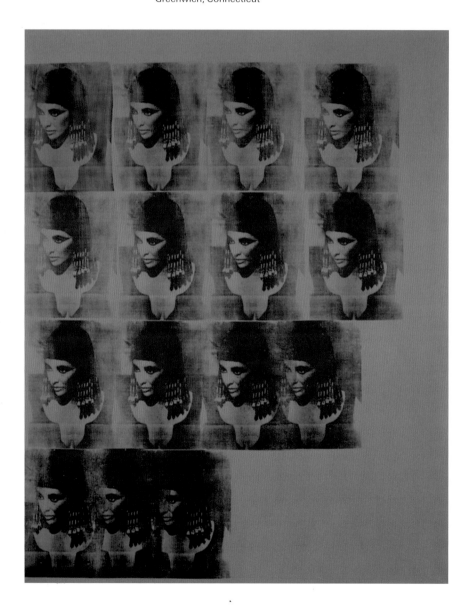

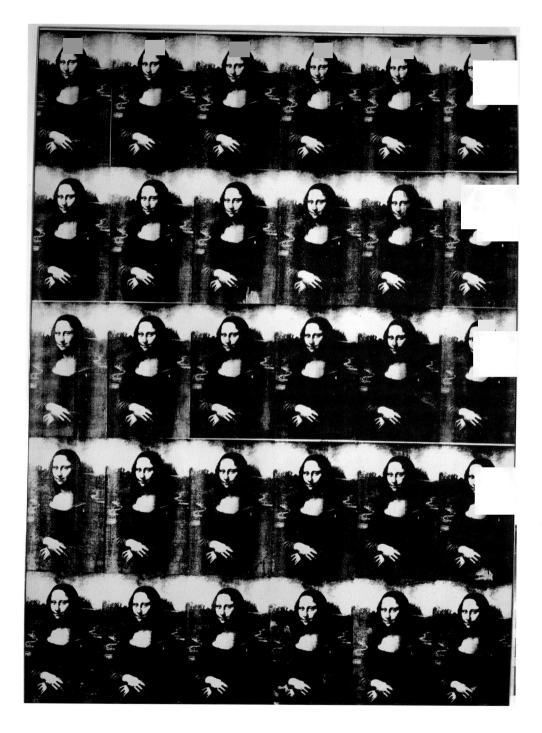

49

36
*Let Us Now Praise Famous
Men (Rauschenberg
Family)* 1963
Silkscreen on canvas
208.2 × 208.2
National Gallery of Art,
Washington DC

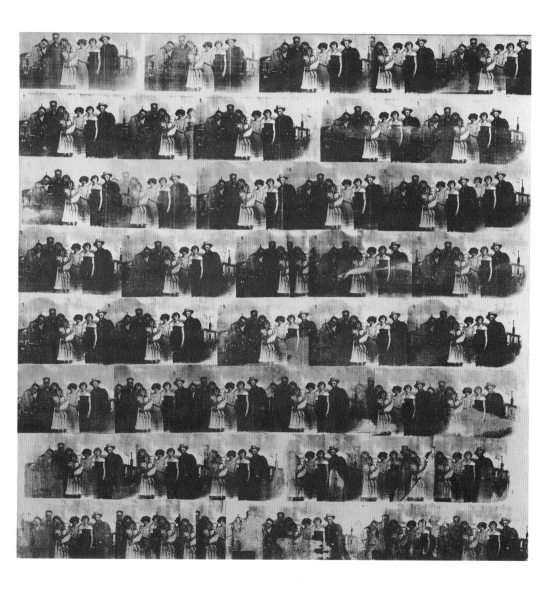

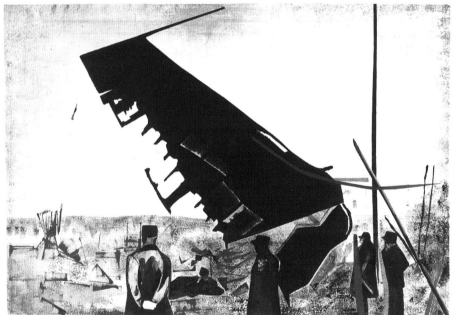

37
129 Die in Jet! 1962
Acrylic paint and graphite
on canvas
254 × 182.9
Museum Ludwig, Cologne

38
Red Disaster 1963/1985
Silkscreen ink on synthetic
polymer paint on canvas
Two panels, each:
236.2 × 203.8
Museum of Fine Arts,
Boston

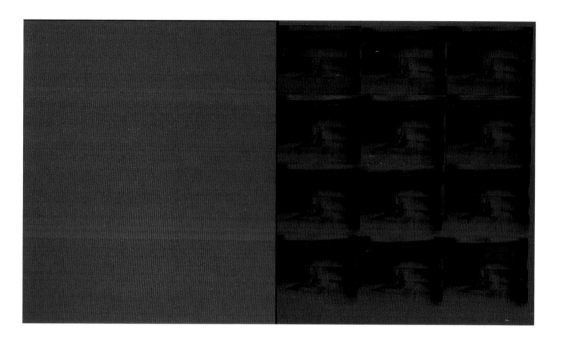

39
Orange Car Crash (Orange Disaster) (5 Deaths 11 Times in Orange) 1963
Silkscreen on acrylic paint on canvas
219.7 × 208.9

GAM, Gallerie Civica d'Arte Moderna e Contemporanea, Turin

40
Saturday Disaster 1963–4
Synthetic polymer paint and silkscreen enamel on canvas
302 × 208

The Rose Art Museum, Brandeis University, Waltham, Massachusetts

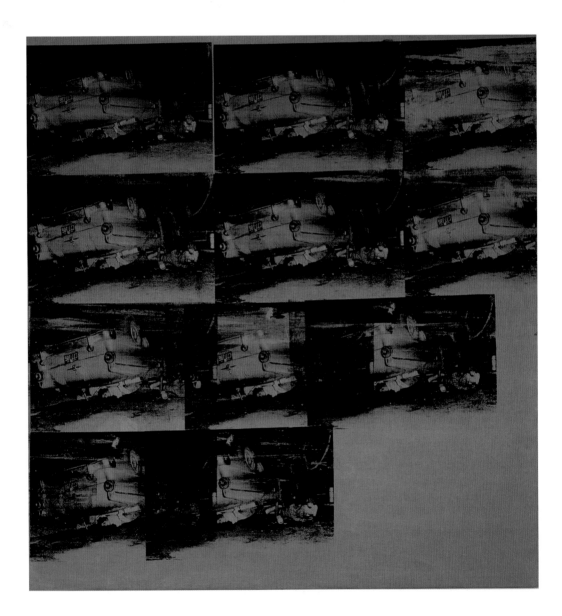

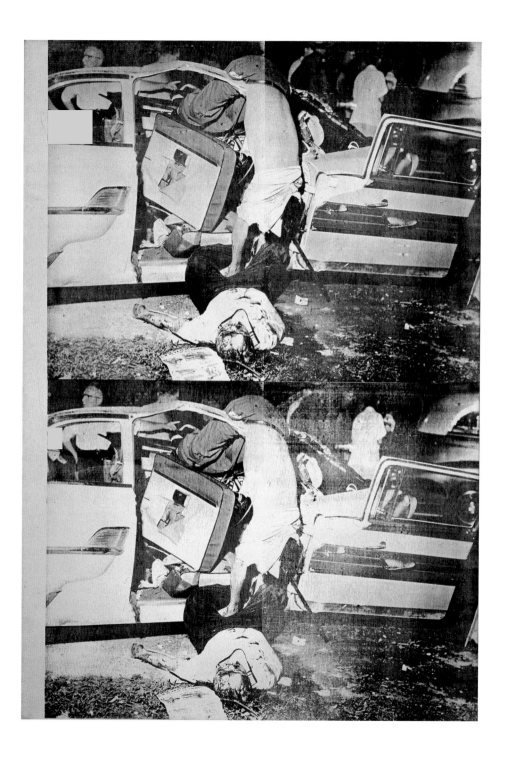

41
Sleep 1963
16mm film, black and white,
silent, 5 hours, 21 minutes
at 16 frames per second
Film still courtesy The Andy
Warhol Museum, Pittsburgh

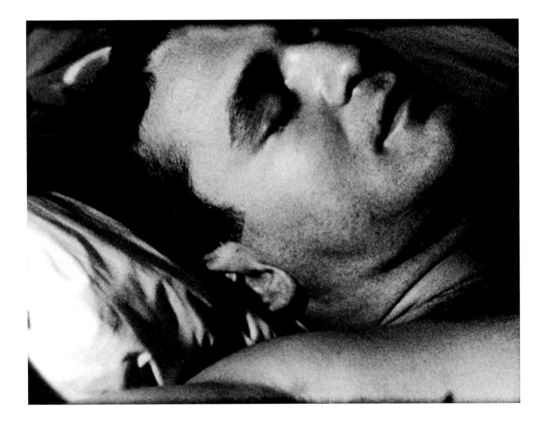

42
Empire 1964
16mm film, black and white,
silent, 8 hours, 5 minutes
at 16 frames per second
Film still courtesy
The Andy Warhol Museum,
Pittsburgh

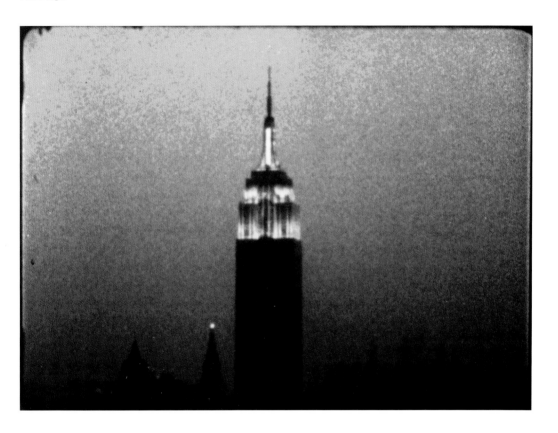

43
Electric Chair 1964
Screenprint and acrylic
paint on canvas
56.2 × 71.1
Tate

44
Twelve Electric Chairs
1964–5
Silkscreen ink and acrylic
paint on canvas
12 parts, each: 55.9 × 71.1

The Brant Foundation,
Greenwich, Connecticut

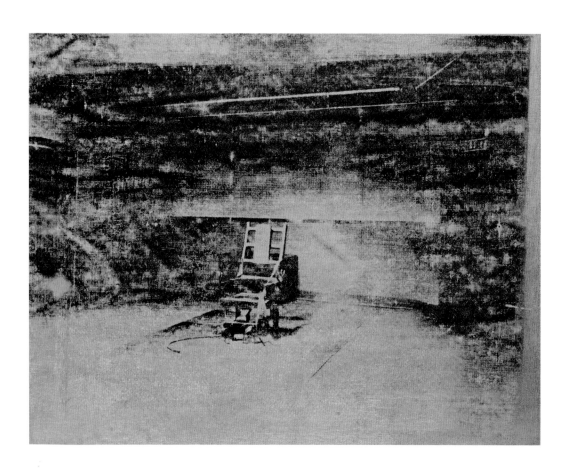

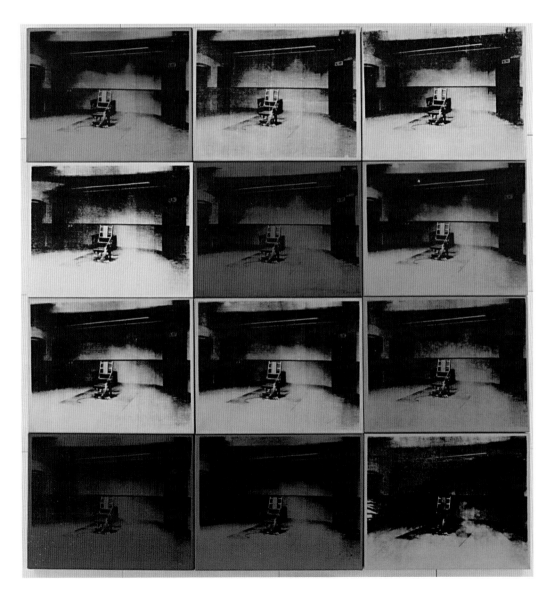

45
Birmingham Race Riot
1964
Screenprint on paper
51 × 61
Tate

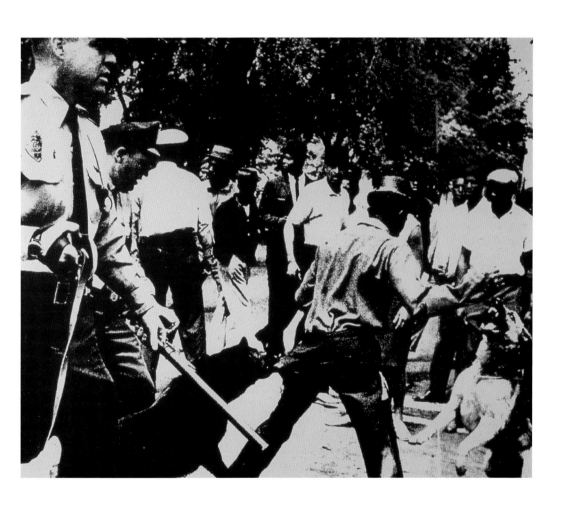

46
Nine Jackies 1964
Acrylic paint and
silkscreen on canvas
153.4 × 122.2
The Metropolitan Museum
of Art, New York

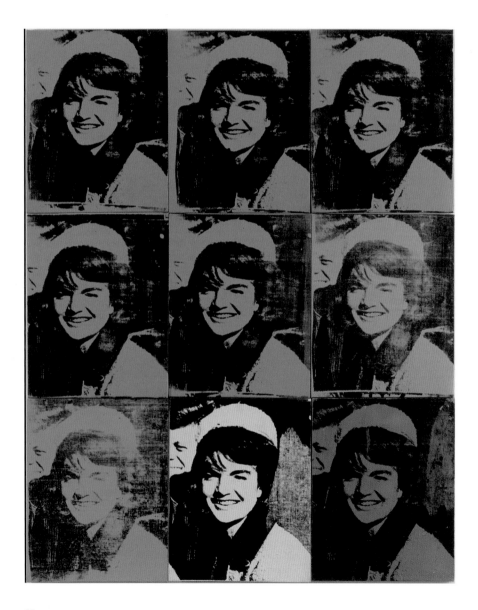

47
Brillo Boxes 1964
Screenprint and ink on wood
Each: 43.2 × 43.2 × 35.6
Philadelphia Museum of Art

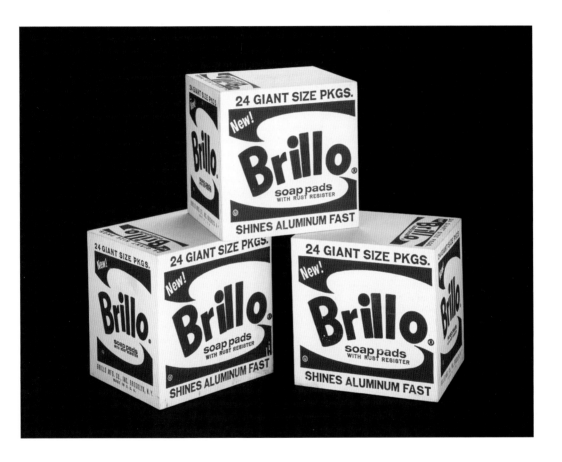

48
Outer and Inner Space 1965
16mm film, black and white,
sound, 66 minutes, or
33 minutes in double screen
Film still courtesy The Andy
Warhol Museum, Pittsburgh

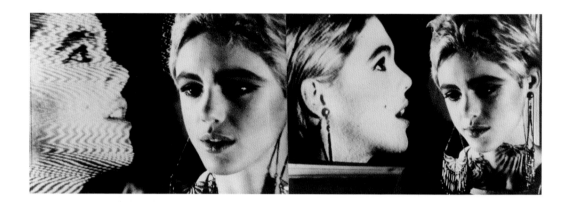

49
Screen Test: Susan Sontag
[ST318] 1965
16mm film, black and white,
silent, 4 minutes 30 seconds
at 16 frames per second
Film still courtesy The Andy
Warhol Museum, Pittsburgh

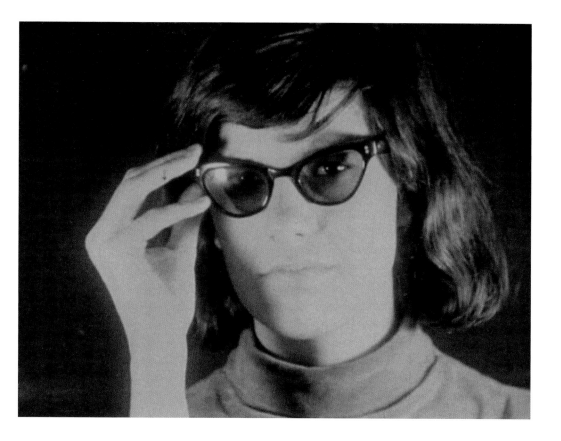

50
Andy Warhol and
Billy Klüver (contributor)
Silver Clouds 1966 [Warhol
Museum Series]
Helium-filled metallised
plastic film

Each: 81.3 × 121.9 × 38.1
The Andy Warhol Museum,
Pittsburgh

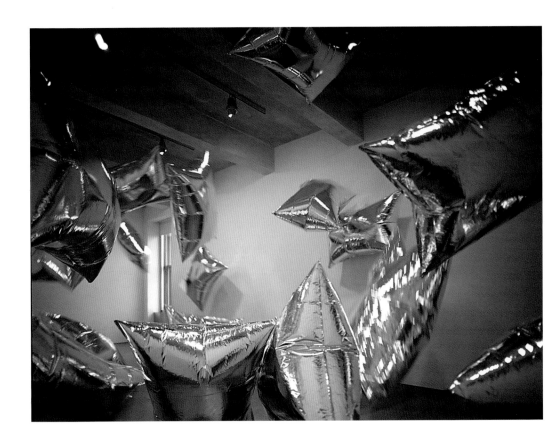

51
*The Velvet Underground &
Nico* 1967
Album cover design
by Warhol
Offset lithograph on
coated record cover stock

with vinyl record album
31 × 31
The Andy Warhol
Museum, Pittsburgh

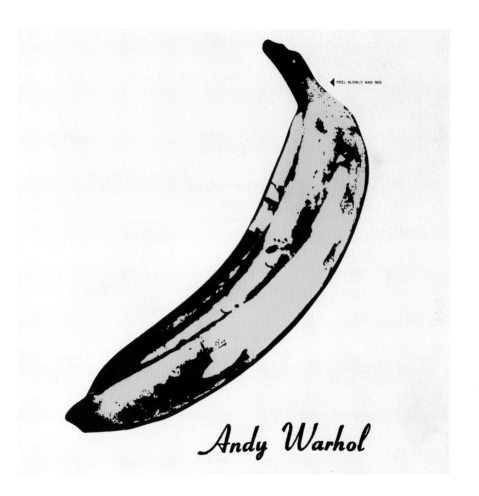

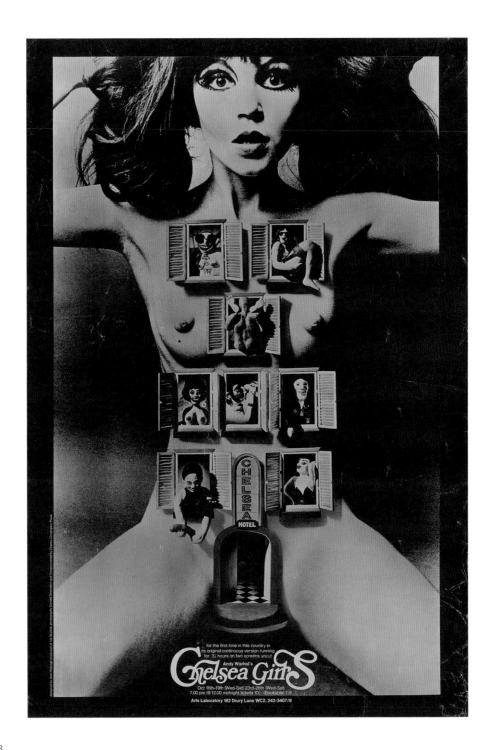

52
Chelsea Girls 1967
Lithograph on paper
76.2 × 51
Tate

53
Warhol's cover concept for
The Rolling Stones' *Sticky
Fingers* album 1971
Photograph by Billy Name,
and design by Craig Braun
Offset lithograph on
coated record cover stock

with vinyl record album
31 × 31
The Andy Warhol
Museum, Pittsburgh

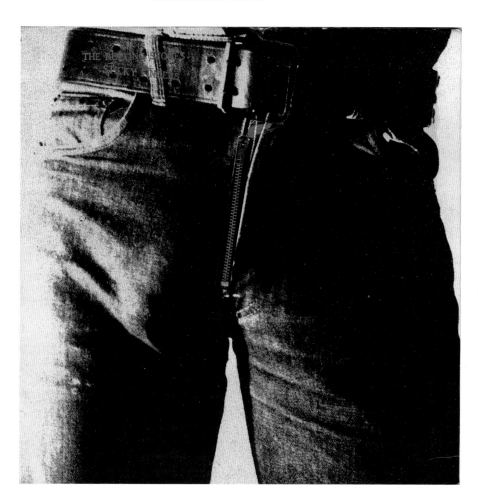

54
Mao 1973
Synthetic polymer paint and
silkscreen ink on canvas
Six parts, each:
448.3 × 346.7
The Art Institute of Chicago

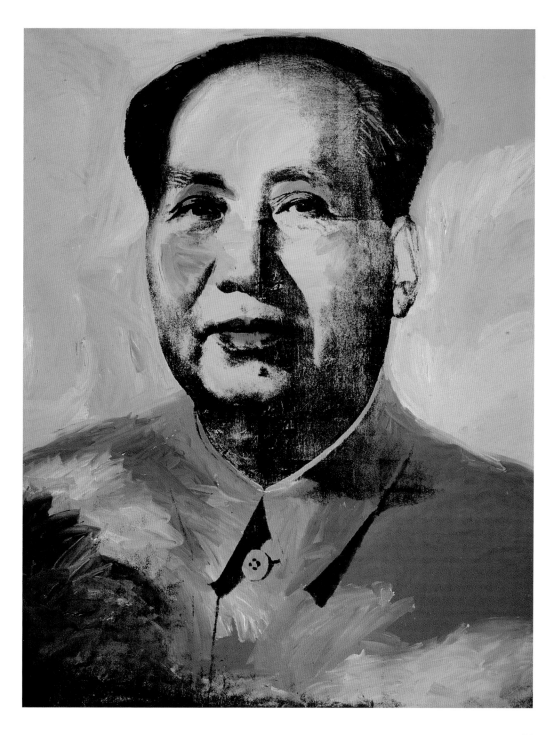

55
Skulls 1976
Acrylic paint and
silkscreen on six canvases
38.3 × 48.3 × 1.8
Tate

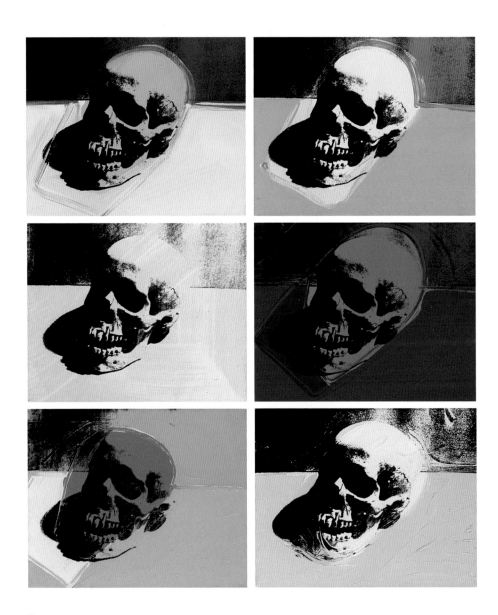

56
*Self-Portrait in Interview
T-shirt* 1977–8
Photograph, colour,
Polaroid, on paper
9.5 × 7.2
Tate

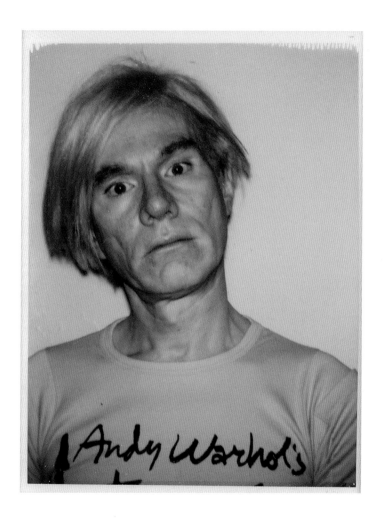

57
Shadows 1979 (detail)
Silkscreen ink and
synthetic polymer paint
on canvas
102 canvases, each:
193 × 132.1

Dia Art Foundation, New
York

58
*Self-Portrait in Profile with
Shadow* 1981
Photograph, colour,
Polaroid, on paper
7.2 × 9.5
Tate

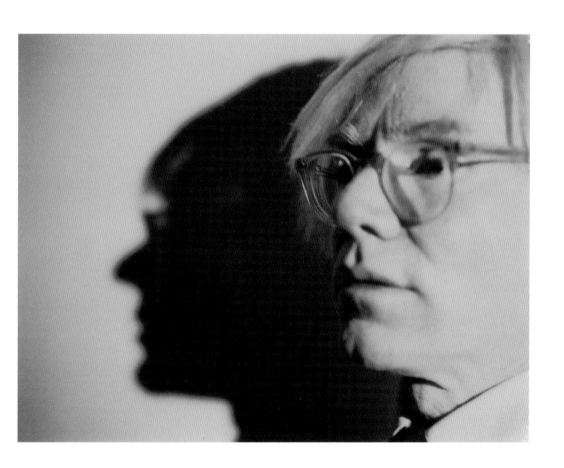

59
Rorschach 1984
Synthetic polymer paint
on canvas
417.2 × 292.1
The Museum of Modern
Art, New York

60
Self-Portrait 1986
Acrylic paint and
screenprint on canvas
203.2 × 203.2
Tate

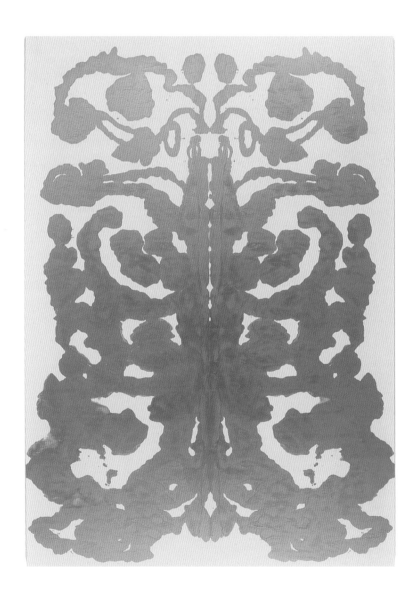

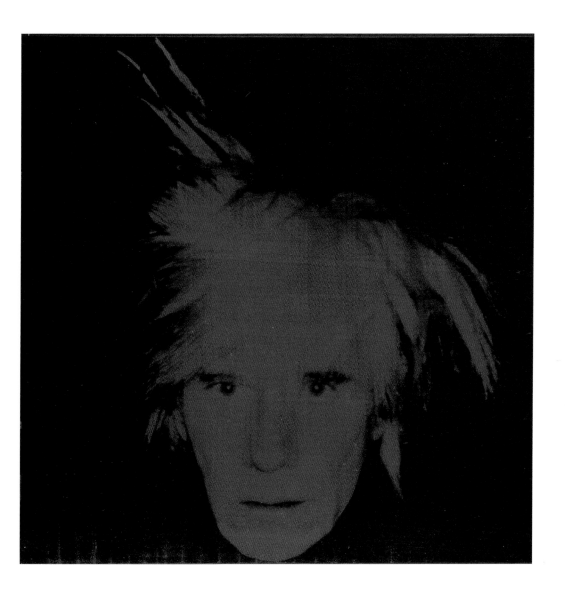

Notes

1. Tina S. Fredericks, 'Remembering Andy,' in Jesse Kornbluth, *Pre-Pop Warhol*, New York 1988, p.12.

2. Warhol, *The Philosophy of Andy Warhol (From A to B and Back Again)*, first published in 1975, London and New York 2007, p.92.

3. Ibid., p.148.

4. Peter Wollen, 'Notes from the Underground: Andy Warhol', in *Raiding the Icebox: Reflections on Twentieth-Century Culture*, first published 1993, London and New York 2008, p.169.

5. Heiner Bastian, 'Rituals of Unfulfillable Individuality: The Whereabouts of Emotions Part One,' in Bastian (ed.), *Andy Warhol Retrospective*, exh. cat., Tate Modern, London 2002, p.16. The present publication is indebted to Antje Dallmann's detailed account of the artist's life, 'Andy Warhol: A Chronology in America,' on pp.287–302 of this exhibition catalogue.

6. Nathan Gluck quoted in Todd Alden, 'Andy Warhol's Literary Oven: Blotted Ink Drawings 1952–1954,' in *Andy Warhol: Strange World, Drawings 1948–1959*, exh. cat., Paul Kasmin Gallery, New York 2008, p.ii.

7. This use of gold in *Baboon* is decorative and opulent, perhaps alluding to the prominence of gold in Byzantine church iconography, and anticipates its use by Warhol in later paintings. Here the blotted-line process is revealed in full, with the original drawing and printed blot presented side by side as mirror images.

8. These features are, as Buchloh continues: 'extreme close-up fragments and details, stark graphic contrasts and silhouetting of forms, schematic simplification, and most important, of course, rigorous serial composition.' Benjamin H.D. Buchloh, 'Andy Warhol's One-Dimensional Art: 1956–1966', in Annette Michelson (ed.), *October Files: Andy Warhol*, Cambridge, MA., and London 2002, p.10.

9. Andy Warhol and Pat Hackett, *POPism: The Warhol Sixties*, first published in 1980, London and New York 2007, p.22.

10. Warhol, *Philosophy*, pp.100–1.

11. Warhol, *POPism*, p.6.

12. Ibid., p.8.

13. Hal Foster, *The First Pop Age: Painting and Subjectivity in the Art of Hamilton, Lichtenstein, Warhol, Richter and Ruscha*, Princeton, NJ 2012, p.120.

14. Warhol, *POPism*, p.28.

15. The photo-emulsion process allowed Warhol to transfer a photographic image directly to the silkscreen, ready for printing, using a light-reactive coating to expose the screen. Warhol worked closely with Gerard Malanga and other assistants to produce his silkscreened canvases.

16. Once again Warhol sent the artworks ahead of time to Los Angeles on an uncut roll of canvas, instructing Irving Blum to cut and stretch the works to fit the accompanying stretchers, and hang the paintings right around the gallery with no gaps, to achieve an intense cluster of Presley's repeating image. On this occasion Warhol attended the opening, where he was introduced to a number of upcoming Hollywood stars, such as Dennis Hopper.

17. Warhol quoted in Gene Swenson, 'What is Pop Art?: Answers from 8 Painters', in *Artnews*, vol.62, no.7, November 1963, p.60.

18. Warhol's close friend Henry Geldzahler (then curator of contemporary art at the Metropolitan Museum of Art, New York) suggested that the newspaper's front page of 4 June 1962 would make a good subject for a painting.

19. See Hal Foster, 'Death in America', *October*, vol.75, Winter 1996, p.39.

20. Warhol, *POPism*, p.77.

21. Ibid., p.112.

22. Ibid., p.142.

23. Susan Sontag's influential 'Notes on Camp' essay was published the same year as her *Screen Test*, in the journal *Partisan Review*, vol.31, no.4, 1964, pp.515–30.

24. See Callie Angell, *Andy Warhol Screen Tests: The Films of Andy Warhol. Catalogue Raisonné: vol.1*, New York 2006.

25. On the screen tests, see Foster, *The First Pop Age*, p.163.

26. As the artist himself commented: 'If anybody wants to know what those summer days of '66 were like in New York with us, all I can say is go see *Chelsea Girls*. I've never seen it without feeling in the pit of my stomach that I was right back there all over again. It may have looked like a horror show – "cubicles in hell" – to some outside people, but to us it was more like a comfort – after all, we were a group of people who understood each other's problems.' Warhol, *POPism*, p.233.

27. In the same month, the first European retrospective of his work opened at Stockholm's Moderna Museet, as Warhol's celebrity status gathered pace both at home and abroad.

28. Warhol, *POPism*, p.343.

29. Warhol, *Philosophy*, p.123.

30. By choosing to paint shadows, Warhol made reference to the negative/positive structure of photography and indeed silkscreen printing, contrasting light and shadow across a sequence of 102 canvases that explored painting's relationship to visual perception.

31. Within *The Last Supper* series some works were based on a line drawing of the fresco rather than a photographic reproduction. In one canvas Warhol superimposed corporate logos for companies such as General Electric and Dove on top of the biblical scene, while others veiled the figures of Christ and his disciplines in a dense layer of camouflage, cross-pollinating with another major Warhol series of this time. For a detailed account of Warhol's 1980s work, see Joseph D. Ketner II (ed.), *Andy Warhol: The Last Decade*, exh. cat., Milwaukee Art Museum, Milwaukee, Munich and New York 2009.

Index

First published 2014 by order of the Tate Trustees by
Tate Publishing, a division of Tate Enterprises Ltd,
Millbank, London SW1P 4RG
www.tate.org.uk/publishing

© Tate Enterprises Ltd 2014

A catalogue record for this book is available from the
British Library

ISBN 978 1 84976 318 9

Designed by Anne Odling-Smee, O-SB Design
Colour reproduction by DL Imaging Ltd, London
Printed in and bound in Italy by Elcograf

Cover: *Marilyn Diptych* 1962 (detail of fig.32)
Frontispiece: *Thirty Are Better Than One* 1963 (detail
of fig.35)

Measurements of artworks are given in centimetres,
height before width.